MOODLES

··· presents ···

Grumpy

This edition published by Parragon Books Ltd in 2015
and distributed by

Parragon Inc.
440 Park Avenue South, 13th Floor
New York, NY 10016
www.parragon.com

Copyright © Parragon Books Ltd 2015

Written and illustrated by Emily Portnoi
Edited by Frances Prior-Reeves

ISBN 978-1-4748-0429-5

Printed in China

MOODLES

··· presents ···

Grumpy

PaRragon

Bath · New York · Cologne · Melbourne · Delhi
Hong Kong · Shenzhen · Singapore · Amsterdam

Welcome
to your moodle book.

"What is a moodle?" I hear you ask. Well, a moodle
is just a doodle with the power to change your mood.
Be it grumpy to glad, happy to sad, or glad back
to mad. Cheaper than therapy, quicker than
chanting chakras, tastier than a cabbage leaf
and sandpaper detox, and less fattening
than chocolate cake!

The moodle: a simple thing that
can really turn your day around.

No matter how grumpy
you're feeling, all you need is
a pen or pencil, imagination, and
an open mind. Be prepared to delve
into your innermost thoughts, ideas,
and concepts. Uncover your subconscious
and lay it bare on the page – admire it,
mock it, and marvel at it. Let the moodle
wisdom penetrate your subconscious and guide
you on a magical mental journey, where the final
stop is a lighter, brighter mood!

Moodle your **GRUMPIEST** frown in the middle of the page. Then turn the book upside down.

Now draw in the rest of your face. *Voilà!*

Draw one thing that has really brought you down today. Then tear out this page, screw it into a tight ball and throw it into the wastebasket — did you get it in first time?

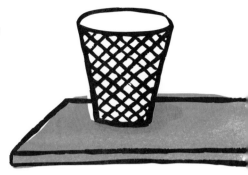

For a more challenging and cathartic version of this moodle, place the wastebasket on a high shelf or use a very small one.

Don't be UNDER the weather.

Moodle yourself above the clouds.

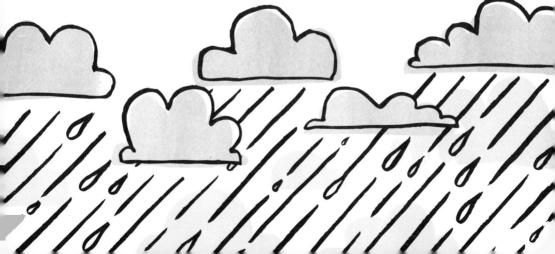

1. Get a pencil.
2. Scribble all your frustration onto this page.
3. Erase it.
4. Repeat until all anger is erased.

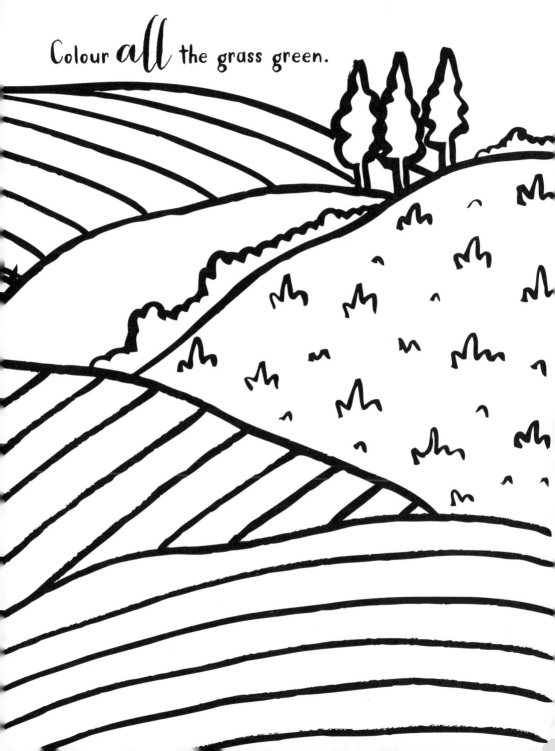

This page has given you lemons.

So why not make lemonade?

Create a **MONSTER** that is the embodiment of your mood!

This Popsicle is about to have a meltdown.

What can you moodle to save it?

Design your own fortune-teller.
Make every fortune fortunate!

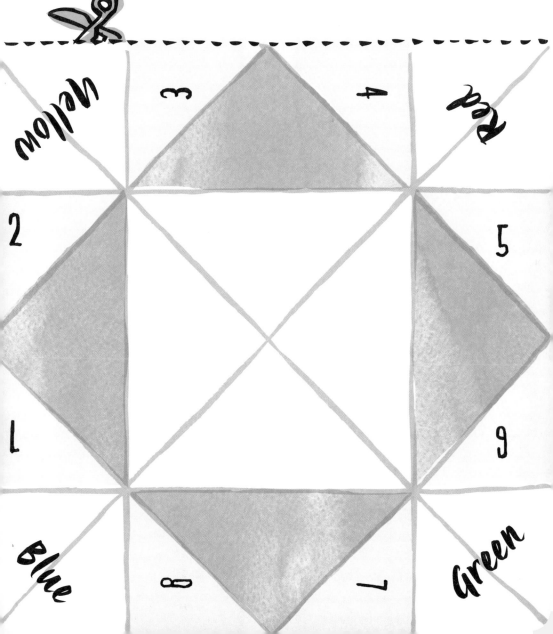

How to make your FORTUNE-TELLER

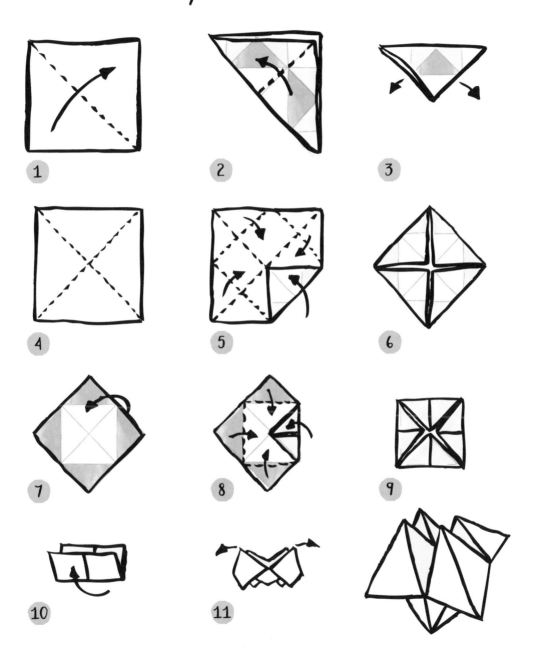

Moodle yourself as a flower –
looking pretty and smelling great is bound to perk you up.

ACKNOWLEDGE YOUR MOODS

and they will pass quicker.
Moodle an emotion a day.

Counting to ten is a great way to calm yourself down, *but* moodling to ten is even better.

Your pencil is possessed by
THE BAD-MOODLE DEMON,
let him take over.

Fill this page with an explanation of why you're in a bad mood; then **scribble** out every other word and read it back.

Draw a **GINORMOUS** grin on this face.

Cut along the dotted lines and wear as a mask!

Draw the word **GRUMPY** in the happiest style you can muster.

Try again.

Draw *three things*

that you are grateful for today.

LOST

MY GOOD MOOD

Description:

Last seen:

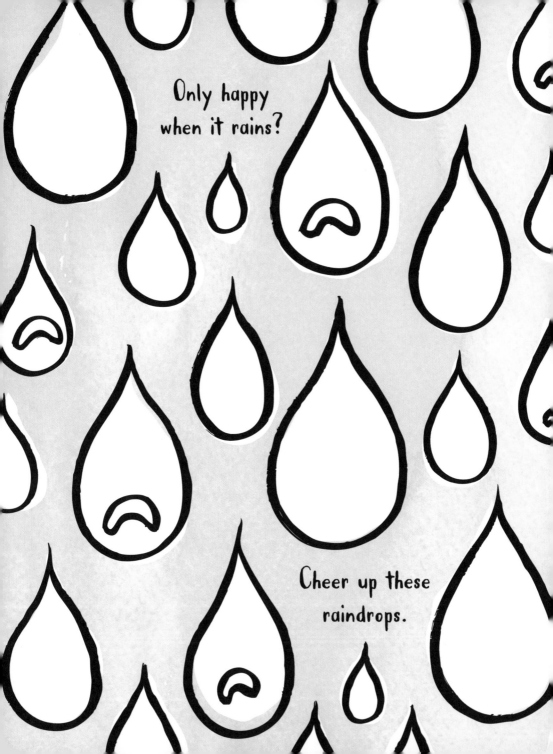

If you had an **AWESOME SIDEKICK** you'd feel **TRULY SUPER.**

Create your ideal sidekick here.

DUMP YOUR EMOTIONAL BAGGAGE.

Moodle all your negative emotions onto these bags.
Tear out this page, take it on vacation, and leave it behind.

Sketch the faces these **moody eyes** belong to
— see if you can cheer them up a bit.

Look on the bright side
— draw with neon pens.

You're *top* of the trumps.

Awesomeness: _____ %

Secret Skill: _____

Best Feature: _____

Moodle your own stats card.

Here's your **fantasy calendar**; fill it in with your ideal life.

Be more creative! Nobody's grading this stuff.

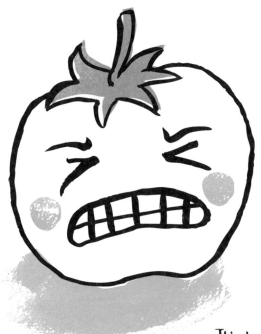

This tomato is having a *bad day.*
Draw it a tomato friend to cheer it up.

Know someone whose face you'd really like to rearrange?

Well, sketch them here; then cut along the dotted lines and reconstruct into an abstract arrangement.

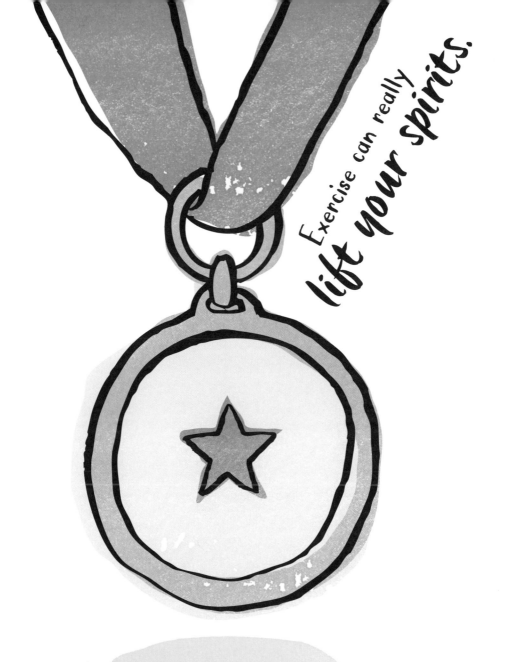

Exercise can really **lift your spirits.**

Lift this book above your head five times.
Great job! Now put your name on this medal.

Need to find your *happy place*?

Sketch it here; then you'll always be able to find it.

Become the superhero
of your own comic strip.

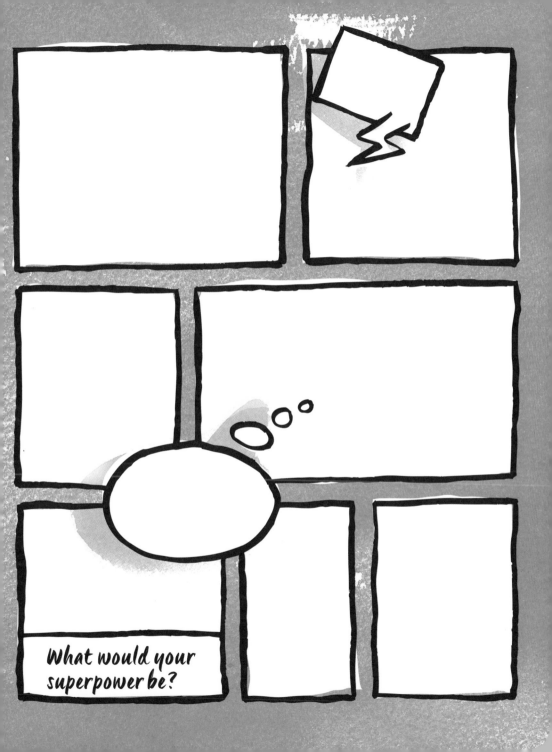

What would your superpower be?

Draw as if you were
four-and-three-quarter-years old.

Misery loves company.
Find a friend and moodle together.

Challenge your own identity.

Moodle 6 possible new signatures for yourself.
1 must contain a cat. 2 must contain hieroglyphs.
1 must be a smiley face. 1 must be in orange.

Embrace the negative!
Only draw the shapes in between objects.

Bad hair day?

Give each of these heads a different style.

Fill up this cookie jar.

Then dip your hand in whenever you need a little sweet comfort.

Try seeing things from a **different** point of view. Put your head between your legs and draw what you see—make sure you don't get too dizzy.

Moodle your ultimate everyday hero here,

using your favorite body parts and
characteristics from people you know.

Make this **spiky** cactus the flowering variety.

Cheer up Mr. Grumpy Gills
by moodling him some fishy friends.

Take leave of your *senses*.
Moodle with your eyes closed.

Moodle **five wishes** for your future onto these crystals. Cut them out and hold them tight for ten minutes a day.

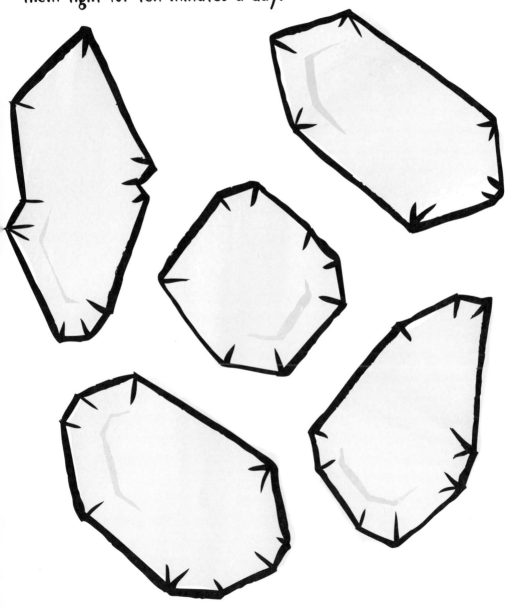

Fill your head **entirely** with happy thoughts and moodles.

Make sure there's no room at all for negative thoughts to creep in.

Focus on the important details.

Moodle your favorite compliment.
Then tear out this page and tape it to your mirror.

Smile! It might never happen!
Moodle your smile here.

A quick trick to banish the blues:
draw around your toes and then moodle
them into a family of foxes.

Tidy home, tidy mind!

Moodle all of your mess
neatly onto these shelves.

MOODLE YOUR GUARDIAN ANGEL.

Here's a **COSMIC** black hole.

Moodle what you would throw in.

Repeatedly write the line
"My anger WILL disappear,"
over and over on this page,
until it is no longer legible.

Draw a picture entirely in shades of **aggressive red**.

Time to *declutter!*

Draw the same moodle six times, using one less line each time.

Moodle the sun coming out.

Moodle
a rainbow.

Moodle
a pot of gold.

Get some perspective.

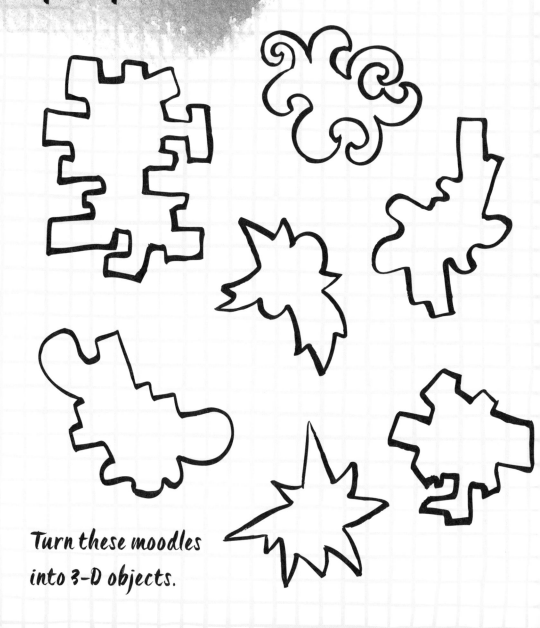

Turn these moodles into 3-D objects.

Try out all the **pens** and *pencils* you own on this page.

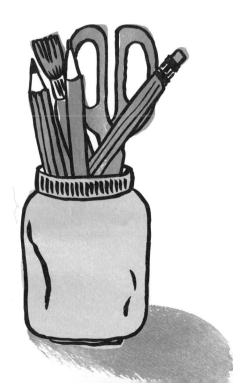

Pick your favorite.

Write a letter of forgiveness to yourself.

Moodle yourself a **very** long fuse.

There's nothing like your favorite TV show to cheer you up.
Sketch your **favorite** TV and movie scenes.

Challenge your bad mood to a duel.

Moodle your own rescue from the *Isle of Glum*.

Count your blessings here.

Winning IS A STATE OF MIND.

Sketch yourself in the number 1 spot on the podium.

Grumpily draw a self-portrait; then draw a **grumpy** self-portrait.

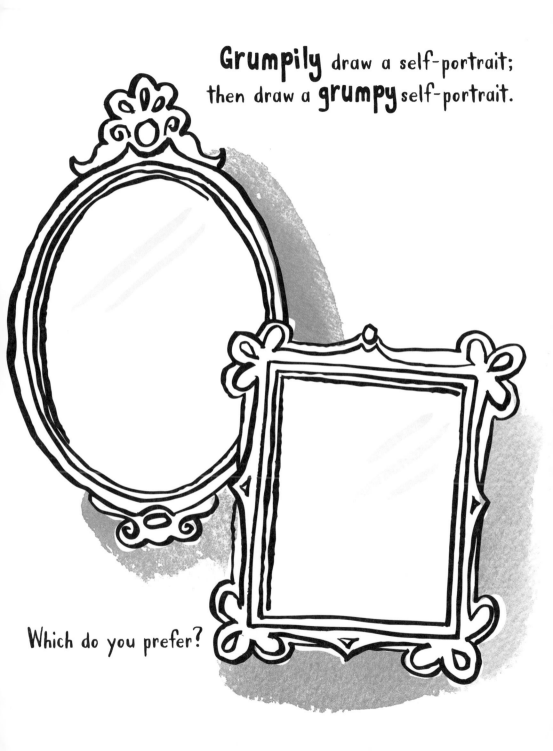

Which do you prefer?

Shift your focus.

Draw something you can see far in the distance.

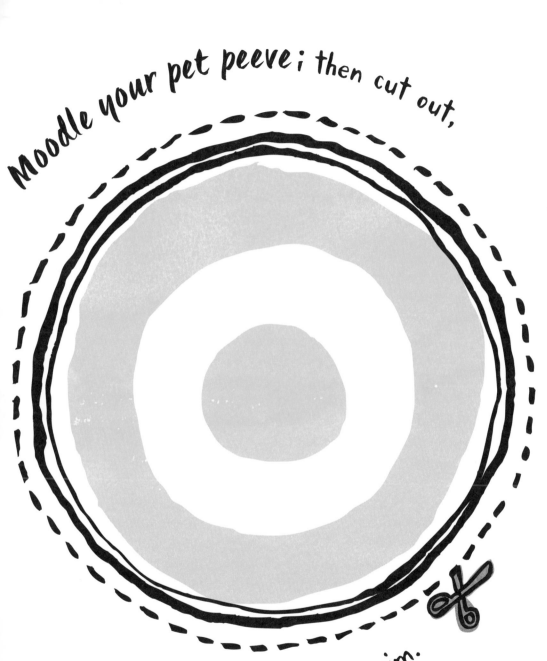

Moodle your pet peeve; then cut out,

pin up, and take aim.

Dance is the perfect way to let go.

Turn the music up and moodle your best dance moves.

Will the sun come out tomorrow?

Draw your week's forecast and try to be optimistic.

MONDAY

TUESDAY

WEDNESDAY

THURSDAY

FRIDAY

SATURDAY

SUNDAY

According to Mark Twain, the best
way to cheer yourself up is to
cheer somebody else up!

Draw a funny *moodle* and show it to as many
people as possible — one person is bound to laugh.

Picture yourself on this raft,
floating slowly downstream.

Draw your personality.

Help these birds build their nest.

1. Tear out this page.
2. Scrunch it into a tiny ball.
3. Unfold.
4. Draw along the crease lines.
5. Find the beauty in the imperfect.

Moodle your **ultimate** ice-cream sundae.

Draw someone you think
could do with a good

SLAP

Then slap the page.

OK, so you're **stuck in a bit of a hole**...
moodle yourself a ladder to climb out.

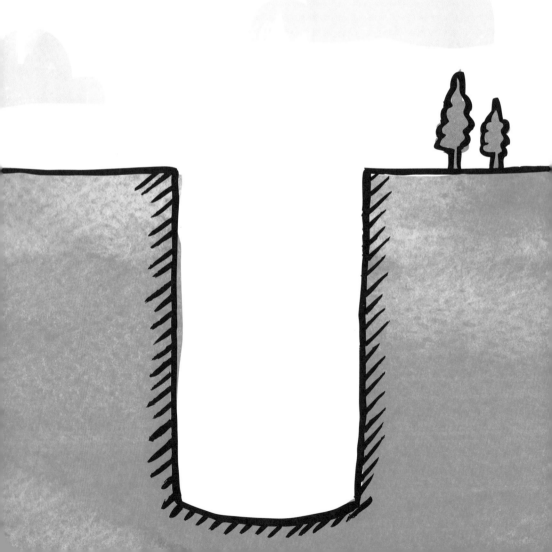

Are you getting enough sleep?

Moodle as many sheep as you can before you doze off.

A face that could curdle milk.

A face eating sour grapes.

Moodle your favorite song.

Make these **blobs** your new creature friends.

Enjoy the **little things**.

Draw five things smaller than your thumbnail.

Moodle yourself a **brand-new species** of animal; make it the **cutest, fluffiest, and smiliest** animal possible.

Name it and make notes about its characteristics.

Quick draw.

Draw the first thing you think of when you read these words:

Gloom

Puddle

Hollow

All moodles complete and wisdom absorbed,
you will by now have reached a state of complete
un-grumpiness. Perhaps you are even floating on a
higher mental plane, unable to even recall what
had annoyed you in the first place.

To complete the ultimate moodle and karmic
U-turn, find someone who looks kind of grumpy
and tell them how awesome they are.